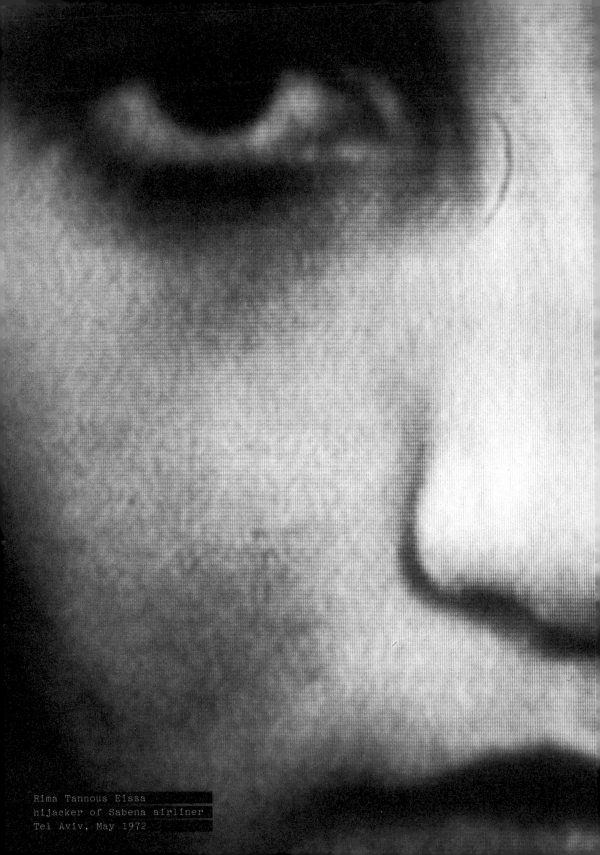

Rima Tannous Eissa
hijacker of Sabena airliner
Tel Aviv, May 1972

ON SEEING, FLYING AND DREAMING
Vrääth Öhner

In his anthropological investigation of cinema, Edgar Morin compares the development of cinema with that of the airplane. Both have conquered the continents; but while the airplane 'fulfilled the most nonsensical dream pursued by mankind since he first beheld the sky: to break free of the Earth', cinema accomplished the exact opposite, namely 'reflecting earthly reality directly'. 'While the airplane moved away from the world of objects, the cinematographer's main aim was to reflect this world in order to be able to scrutinize it more closely.' The point of Morin's little story about a historical coincidence is that the airplane and cinema soon came to swap roles. Due to its usefulness, the airplane obediently fitted in to the world of machines and became an expedient instrument for travel, trade and warfare. Film, on the other hand, 'rose up into a sky of dreams,(…) populated by adorable figures who had fled earthly reality, whose servant and mirror it evidently had been planned to be'.[1]

Of course, this story does not tell us the whole truth; it fails to mention the links that film has had, and still has, with trade and war, for example. It is a falsifying tale whose sole purpose is to present familiar facts from an unaccustomed perspective. But according to Friedrich Nietzsche, this 'perspectivism' is the last possibility of truth left to us because, by merit of its apparent narrowness, it at least preserves us from the greatest illusion of all, namely that such a thing as an objective or universal truth exists at all.

Johan Grimonprez follows an analogous structural principle in dial H-I-S-T-O-R-Y, although the objects of his examination are slightly different: Film has been replaced by television, the airplane has been replaced by the air disaster, and the dream is embodied, at least for a while (under the conditions of the Cold War), in the figure of the terrorist who occupies television and airplane alike. In 1997, in the terms of the history proposed by dial H-I-S-T-O-R-Y, we are now in a completely different situation again: There are bombs that explode without warning, bombs that various political liberation movements claim to have planted (Lockerbie), and there are honeymoon couples who film plane crashes by pure chance.

**

The title, dial H-I-S-T-O-R-Y, refers to conceptual issues in the same way as the video itself: Is it really possible to call history? What sort of apparatus will make the connection? Will history answer? And most importantly: Who would make such a call and why? The idea that it is possible to call history in the first place requires a set of stable relations: There is history, there is someone with a desire to find something out or just chat, and there is a channel which is able to create such a connection. In fact, no part of this scenario is true, or even as unambiguous as implied by the description: History is a fiction which, under certain conditions, can confuse reconstructed history with the past as it 'really' was. Subjective interest in history is based on underlying prerequisites which exceed the subject's reflexivity. After all, the channel is transparent in the first place thanks to the exclusion of third parties, the demon, white noise. Showing that calling history, creating a type of 'supermarket history', is possible therefore means at the same time pointing out changes in the conditions under which history is produced and represented in a critical way.

'Where once [history] was something one read about, inspected through stone monuments and written documents, drew lessons from or tried to leave behind, it now appears to exist in suspended animation, neither exactly "behind" us, nor part of our present, but shadowing us rather like a parallel world, hyper-real and unreal at the same time,' wrote Thomas Elsaesser.[2] The history he was referring to is the one which has been recorded in images and sounds; it is a television history and therefore our history: We can call it because, when history still existed in the zone between event and representation, this type of history already called us (as described by Althusser), as ideological subjects and subjects of ideology, i.e. subject to ideology. In dial H-I-S-T-O-R-Y this situation is given an unambiguous name: The claim is made that the reporting of daily news has now replaced narratives of social events in novel form. This cancels out not only the temporal difference between past and present, which is constitutive for all narratives, but also the spatial difference between observer and object: Society is no longer reflected in the mirror of an individual perception but only in an image of itself.

As soon as it was able to do so, television began reporting on skyjacking all around the globe. It derived advantages from this by availing itself of the dramatic possibilities offered by a hijack (above all, the time frame between the unforeseeable attack and the conclusion of negotiations concerning release of hostages that allows enough time to set up cameras). Due to the fact that hijacks were events that lasted an (increasingly) long time, television was able

to become established as a medium that could update its viewers at any time on the particular event with pictures and sound. A form of event direction that could not help but underscore the spectacular aspect of every single hijack in order to focus on the current one as something quite unique and distinctive (first transatlantic hijack, first live TV broadcast of a hijack, first attack on a skyjacked plane, etc.). Television emphasizes the difference of the similarity that is the only material suitable for television screening. In this way, this similar event can be presented as a whole, complete occurrence comprising all differences.

When Grimonprez assembles a chronology of hijacks on the basis of television images in *dial H-I-S-T-O-R-Y*, we see that they show us almost nothing at all, or rather, what we see are the gaps and spaces that the television image has to mask because of its immediacy, because it has been broadcast simultaneously with the occurrence of the event, so that it can be perceived as an image. In this sense, the television image corresponds exactly to the definition of the visual as given by Serge Daney. The television image, he maintains, is an image that lacks reference to the other and in which this lack is no longer noticed. 'An image is what I call something that is still based upon a visual experience, and visual is what I call optical confirmation of the procedure of powers (of a technological, political, military or commercial nature) that, as a commentary, aims merely to elicit a sense of "Got it!".'[3] The history of skyjacks in television images is a visual and thus blind history, which is why to Grimonprez it can become a history of this blindness.

However, this makes it necessary to link television images with other images (with a flying house reminiscent of The Wizard of Oz, with images from a training video for the event of a hijacking, with pictures of the other side of the Iron Curtain: the dead Lenin, Stalin in mourning, the people in formation), and to add to the montage a voice-over that only makes indirect reference (Grimonprez uses quotations from two novels by Don DeLillo, *White Noise* and *Mao II* for this purpose). And yet there would seem to be a close tie between Grimonprez' and DeLillo's intentions: *White Noise*, for example, not only records the vibrations of American consumerism, it not only contains the theories on the subject of death and conspiracy that Grimonprez cites, but rather its very title refers to both ends of the information spectrum that is also the focus of *dial H-I-S-T-O-R-Y*. In terms of information theory, *White Noise* not only implies the pure information beyond any redundancy, but also the disinformation that arises as a result of the unconnectedness of each individual piece of information with all others—to which the dial in *dial H-I-S-T-O-R-Y* refers: At the push of a button, we can obtain such a wealth of information from the Internet that we no longer know where to start, Grimonprez noted in an interview.[4] Above and beyond that, white noise in the acoustic field embodies the only audible range that we perceive as static, as unmoving.

Between an unreadable history and a superabundance of available history, *dial H-I-S-T-O-R-Y* seeks to arrive at statements that do not, in turn, lay claim to the static essence of a viewpoint, but rather make history describable as a field of virtual (re)connections. *dial H-I-S-T-O-R-Y* operationalizes the co-presence of several different points-of-view, thereby crossing the borders of any fictional narrative. As Elena Esposito noted, the term 'virtual' comes from the field of optics and refers to the reflections of images in a mirror. 'The mirror does not "represent" [in contrast to fiction] an alternative reality for the observer (which can be attributed to a different observer); it "presents" the real reality from a different point-of-view, thereby expanding the observer's field of observation.'[5] The reflection refers not to the differentiation between reality and fiction but to the conditions under which the observation takes place: Because the virtual history suggested by *dial H-I-S-T-O-R-Y* comprehends television images as reflections of social progress which we are as yet unable to describe, it does not reflect them as fictional reality but as the reality of fiction.

To return to Morin: after cinema had outstripped the airplane as a dream factory, the dream of flying returned on television as a nightmare.

1
Edgar Morin, *Der Mensch und das Kino*, Stuttgart, 1958, p.9

2
Thomas Elsaesser, *One train may be hiding another: private memory, history and national identity*, in: *Screening the Past*, No. 6, 1999, www.latrobe.edu.au/screeningthepast

3
Serge Daney, *Vor und nach dem Bild*. In: *politics/poetics. Das Buch zur Dokumenta X*, Ostfildern, 1997, p.610

4
Supermarket History. Johan Grimonprez in an interview with Catherine Bernard, in: *Parkett*, No. 53, Zurich, 1998, p.12–18.

5
Elena Esposito, *Fiktion und Virtualität*, in: Sybille Krämer (Ed.), *Medien, Computer, Realität*, Frankfurt am Main, 1998, p.287

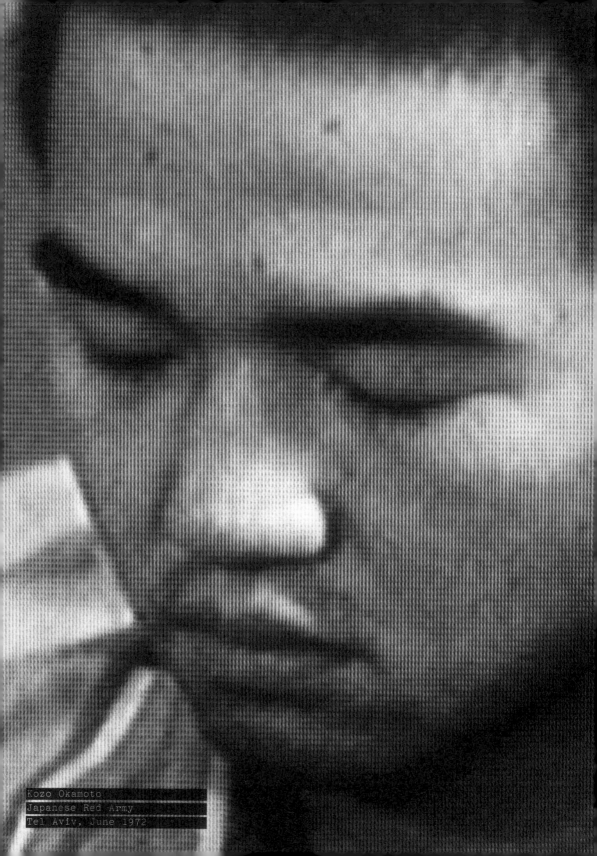

Kozo Okamoto
Japanese Red Army
Tel Aviv, June 1972

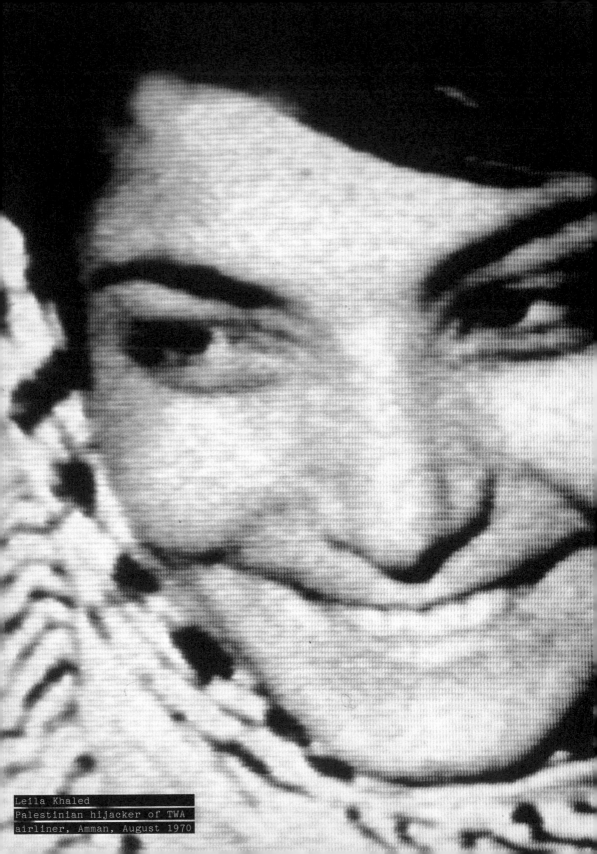

Leila Khaled
Palestinian hijacker of TWA
airliner, Amman, August 1970

Raffaele Minichiello
first transatlantic hijack
Rome, November 1969

INS
COMM
HE

ERT

ERCIAL

RE

anonymous hijacker
Panama, 1970

Mouna Abdel Majid
Palestinian hijacker
Amman, August 1970

NOVELISTS AND
TERRORISTS PLAY A
ZERO-SUM GAME.
WHAT TERRORISTS
GAIN, NOVELISTS LOSE

DON DELILLO, MAO II

Black Power Family
Delta Airlines hijacking to Algiers
January 1972, Algiers

A HOLIDAY FROM HISTORY
and other real stories

by Slavoj Žižek

Alain Badiou once identified the 'passion for the Real" as the key feature of the 20th century. In contrast to the 19th century with its utopian projects of the future, the 20th century aimed at delivering the thing itself. The ultimate defining experience of the 20th century was the direct experience of the Real as opposed to the everyday social reality — the Real in its extreme violence as the price to be paid for peeling off the deceptive layers of reality.

Already, in the trenches of World War I, Carl Schmitt celebrated face-to-face combat as *the* authentic encounter: authenticity resides in the act of violent transgression — from the Lacanian Real to Bataillean excess. In the domain of sexuality itself, the epitome of this 'passion for the Real' is Oshima's *Empire Of the Senses* (1976), a Japanese cult movie in which the lovers' relationship radicalizes into mutual torture, resulting in death. The option one gets on hard-core porn websites to observe the interior of a vagina from the viewpoint of a tiny camera mounted in the tip of the penetrating dildo — is that not the ultimate iconography of the 'passion for the Real'? At this extreme point, a shift occurs: when one gets too close to the desired object, erotic fascination turns to disgust at the Real of bare flesh.

Is the so-called fundamentalist terrorism not also an expression of this 'passion for the Real'? In Germany during the early 1970s, the collapse of the New Left, and the student protest movement, produced an outgrowth: the Red Army Faction (the Baader-Meinhof 'gang'.) Its underlying premise was that the failure of the student movement demonstrated

1. See Alain Badiou, *Le siècle*, forthcoming from Éditions du Seuil, Paris.

how deeply the masses are immersed in the consumerist apolitical stance: it is not possible to awaken them through standard political education. A more violent intervention is needed to shatter the ideological numbness. Only direct intervention, such as bombing supermarkets, would do the job. At a different level, doesn't today's 'fundamentalist terror' hold the same for us? Is this not the goal: to awaken us, Western citizens, from our numbness, from our immersion into our everyday ideological universe?

These examples point to the fundamental paradox of the 'passion for the Real': it culminates in its apparent opposite, as a *theatrical spectacle* – from the Stalinist show trials to spectacular terrorist actions.[2] The key to this reversal resides in the ultimate impossibility of drawing a clear distinction between deceptive reality and a positive kernel of the Real. Every positive bit of reality is suspicious *a priori*. We know from Lacan that the Real Thing is ultimately another name for the Void. The pursuit of the Real equals total annihilation, a (self)destructive fury in which the only way to track the distinction between the semblance and the Real is to STAGE a fake spectacle.

In today's market, we find a whole series of products deprived of their malignant properties: coffee without caffeine, cream without fat, beer without alcohol. The list goes on: virtual sex as sex without sex; the Colin Powell doctrine of warfare with no casualties (on our side of course) as warfare without warfare; the contemporary redefinition of politics as the art of expert administration as politics without politics; today's tolerant liberal multiculturalism as an experience of the Other deprived of its Otherness. Virtual Reality simply generalizes this habit: it provides a reality deprived of its substance, the hard resistant kernel of the Real. In the same way decaffeinated coffee smells and tastes like real coffee without being real coffee, Virtual Reality is experienced as reality without being reality. What awaits us at the end of this process of virtualization is the experience of 'real reality' itself becoming a virtual entity. For the large majority of the public, the World Trade Center explosions were events on the TV screen. Was not the often-repeated footage of frightened people running towards the camera, the giant cloud of dust from the collapsing tower behind them, reminiscent of spectacular disaster movies? A special effect to outdo all the others? As Jeremy Bentham already knew, reality is the best appearance of itself.

2 At a more general level, one should note how Stalinism, with its brutal 'passion for the Real', its readiness to sacrifice millions of lives for its goal, to treat people as dispensable material, was at the same time the regime most sensitive to *maintaining the proper appearance*: it reacted with a total panic whenever there was a threat that this appearance would be disturbed (say, that some accident which renders clear the failure of the regime will be reported in the public media: there were, in the Soviet media, no black chronicles, no reports on crimes and prostitution, not to mention workers' or public protests).

Was the bombing of the World Trade Center—in relation to Hollywood disaster movies—not unlike snuff pornography versus ordinary sadomasochistic porn? This is the element of truth in Karl-Heinz Stockhausen's provocative statement that the planes hitting the WTC towers was the ultimate work of art: one can effectively perceive the collapse of the WTC towers as the climactic conclusion of 20th-century art's 'passion for the Real'. The 'terrorists' didn't do it primarily to provoke real material damage, but FOR THE SPECTACULAR EFFECT OF IT. For days after September 11, 2001, our gaze was transfixed by the images of a plane hitting one of the WTC towers. We were all forced to experience this 'compulsion to repeat' and *jouissance* at its purest. Beyond the pleasure principle: we wanted to see it again and again, the same shots repeated ad nauseam, and the uncanny satisfaction we got from them. When we watched the two WTC towers collapsing on the TV screen, the falsity of 'reality TV shows' became apparent. Even if these shows are 'for real', people still act in them—they simply play themselves. The standard disclaimer in a novel ('characters in this text are fictional, any resemblance with real life characters is purely contingent') holds true for the participants of reality soaps.

The authentic 20th-century impulse to penetrate the Real Thing (ultimately the destructive Void), through the cobweb of semblances which constitute our reality, culminates in the thrill of the Real as the ultimate 'effect'. The ultimate American paranoid fantasy is of the everyman living in a small idyllic, consumer paradise, who suddenly begins to suspect that the world he lives in is fake. It is a spectacle staged to convince him that he lives in the 'real world', with all the people around him as actors and extras in a gigantic ruse. The most recent example of this is Peter Weir's *The Truman Show* (1998), in which Jim Carrey plays a small-town clerk who gradually discovers the truth: he is the hero of a 24-hour TV show. His hometown is a set constructed on a gigantic studio lot, with cameras permanently trained on him. Its predecessor is Philip Dick's *Time Out of Joint* (1959), in which the hero, living a modest daily life in a small town in 1950s California, gradually discovers that the whole town is fake. A reality staged to keep him satisfied. The underlying truth of *Time Out of Joint* and *The Truman Show* is that the late-capitalist consumerist Californian paradise, in its very hyper-reality, is IRREAL, without substance, deprived of material inertia.

The same 'de-realization' of the horror went on after the WTC bombings. While the number of victims is repeated all the time, it is surprising how little of the actual carnage we see: no dismembered

bodies, no blood, no desperate faces of dying people. In clear contrast, reports of Third-World catastrophes produce gruesome details: Somalis dying of hunger, raped Bosnian women, men with slit throats. These images are always accompanied with the advance warning: 'some of the images you will see are extremely graphic and may shock children'. A warning which we NEVER heard in the reports on the WTC collapse. More evidence, even in these tragic moments, of the distance which separates Us from Them. Their reality is maintained: the real horror happens THERE, not HERE.[3]

Christopher Isherwood gives expression to this unreality of the American daily life, as exemplified by the motel room: 'American motels are unreal! They are deliberately designed to be unreal. The Europeans hate us because we've retired to live inside our advertise-ments, like hermits going into caves to contemplate.' Years ago, a series of science-fiction films like *Zardoz* (1973) or *Logan's Run* (1976) predicted today's postmodern predicament: the isolated community living an aseptic life, longs to experience the real world of material decay.

Is the endlessly repeated footage of the plane approaching and hitting the second WTC tower not a real-life version of a Hitchcock scene from *The Birds* (1963)? Superbly analyzed by Raymond Bellour, in one scene Melanie approaches the Bodega Bay pier in a small boat when a single bird, first perceived as an indistinguishable dark blot, unexpectedly enters the frame from above right and hits her head.[4] Was the plane hitting the WTC tower not the ultimate Hitchcockian blot, an anamorphic stain denaturalizing the familiar New York skyline?

The Wachowski brothers' hit *The Matrix* (1999) brought this logic to its climax: the material reality we all experience and see around us is a virtual one, generated by a gigantic mega-computer to which we are all attached. When the hero (played by Keanu Reeves) awakens into the 'real reality', he sees a desolate landscape littered with charred ruins—the remains of Chicago after a global war. The resistance leader Morpheus utters the ironic greeting: 'Welcome to the desert of the real'. Didn't something similar take place in New York on September 11? Its citizens were introduced to the 'desert of the real'. Corrupted by Hollywood, the landscape and the footage we saw of the collapsing towers could not but remind us of the most breathtaking high-budget disaster scenes.

3 Another case of ideo-logical censorship: when firemen's widows were interviewed on CNN, most of them gave the expected performance: tears, prayers... all except one of them who, without a tear, said that she does not pray for her deceased husband, because she knows that prayer will not get him back. When asked if she dreams of revenge, she calmly said that that would be the true betrayal of her husband: if he were to survive, he would insist that the worst thing to do is to succumb to the urge to retaliate... useless to add that this fragment was shown only once and then disappeared from subsequent repetitions of the same block.
4 See Chapter III in Raymond Bellour, *The Analysis of Film*, Bloomington: Indiana University Press 2000.

GET KILLED,
AND MAYBE THEY WILL
NOTICE YOU

DON DELILLO, MAO II

anonymous skyjacker
St.Petersburg, February 1993

When we hear how the bombings were a totally unexpected shock, how the unimaginable Impossible happened, one should recall the other ultimate catastrophe at the beginning of the 20th century: the sinking of the Titanic. Also a shock, but its space was already prepared in ideological fantasy, since the Titanic was the symbol of 19th century industrial might. Does not the same hold true for these bombings? Not only did the media bombard us constantly with the terrorist threat; this threat was also (very obviously) libidinally invested. Just recall the slew of movies ranging from *Escape From New York* (1981) to *Independence Day* (1996). With the often-mentioned association of the attacks in Hollywood disaster movies, the unthinkable had happened: America got what it fantasized about, and this was the greatest surprise.

The ultimate twist in this link between Hollywood and 'the war against terrorism' occurred when Pentagon solicited help from Hollywood. In early October 2001, the press reported that a group of Hollywood scenarists and directors specialized in catastrophe films, was established at the instigation of the Pentagon. The aim was to imagine possible scenarios of terrorist attacks and how to fight them. And the collaboration continues: in November, a series of meetings were held between White House advisors and top Hollywood executives about coordinating the war effort and establishing Hollywood's role in the 'war against terror'. The idea was to get the right ideological message across — not just to an American audience but also a global one: this is the ultimate empirical proof that Hollywood effectively functions as an 'ideological state apparatus'.

One can invert the standard reading that the WTC explosions were the intrusion of the Real shattering our illusory Sphere. On the contrary, prior to the WTC collapse we lived in our reality, perceiving Third-World horrors as something not effectively part of our social reality, as something that existed (for us) as a spectral apparition on the (TV) screen. On September 11 this screen apparition entered our reality. It was not the reality that entered our image, but the image that entered and shattered the symbolic coordinates which determine what we experience as reality. After September 11, the premieres of many 'blockbuster' movies with scenes reminiscent of the WTC collapse were postponed, or even shelved. It is actually the 'repression' of the fantasmic background responsible for the impact of the WTC collapse. The point is not to reduce the WTC collapse to just another media spectacle. Reading it as a catastrophe version of porno snuff flicks; the question we should have asked ourselves when we stared at the TV

That the September 11 attacks were popular fantasies long before they effectively took place provides yet another case for the twisted logic of dreams. It's easy to account for the fact that poor people around the world dream about becoming Americans. So, what do well-to-do Americans, saturated in their well-to-do-ness, dream of? About a global catastrophe that would shatter their lives. Why? This is what psychoanalysis is about: to explain why, in the midst of abundance, we are haunted by the nightmarish visions of catastrophe.

This paradox points to Lacan's notion of 'traversing the fantasy' as the concluding moment of psychoanalytic treatment. This notion perfectly fits the common-sense idea of what psychoanalysis should do: liberate us from the hold of idiosyncratic fantasies and enable us to confront reality the way it effectively is! However, this is NOT what Lacan has in mind, but almost the exact opposite. In our daily existence, we are immersed in 'reality' (structured by fantasy), and this immersion is disturbed by symptoms that bear witness to the fact that another repressed level of our psyche resists this immersion. To 'traverse the fantasy' therefore paradoxically means *fully identifying oneself with the fantasy* — namely with the fantasy which structures the excess resisting our immersion into daily reality.[5]

The dialectic of semblance and Real cannot be reduced to the fact that the virtualization of our daily lives gives rise to the irresistible urge to 'return to the Real', to regain the firm ground in some 'real reality'. THE REAL WHICH RETURNS HAS THE STATUS OF ANOTHER SEMBLANCE: *precisely because it is real, i.e. on account of its traumatic/excessive character, we are unable to integrate it into (what we experience as) our reality, and are therefore compelled to experience it as a nightmarish apparition.* This is what the captivating image of the collapse of the WTC was: an image, a semblance, an 'effect', which, at the same time, delivered 'the thing itself'.

This 'effect of the Real' is not the same as what Roland Barthes called *l'effet du réel*: it is rather its exact opposite, *l'effet de l'irréel*. In contrast to the Barthesian *l'effet du irréel*, in which the text makes us accept as 'real' its fictional product, here, the Real itself has to be perceived as a nightmarish irreal spectre. Usually we say that one should not mistake fiction for reality – recall the postmodern doxa in which 'reality' is a

5 Or to quote a succinct formulation by Boothby:'"Traversing the phantasy" does not mean that the subject somehow abandons its involvement with fanciful caprices and accommodates itself to a pragmatic 'reality', but precisely the opposite: the subject is submitted to that effect of the symbolic lack that reveals the limit of everyday reality. To traverse the phantasy in the Lacanian sense is to be more profoundly claimed by the phantasy than ever, in the sense of being brought into an ever more intimate relation with that real core of the phantasy that transcends imaging.' Richard Boothby, *Freud as Philosopher*, New York: Routledge 2001, pp. 275-276.

discursive product, a symbolic fiction which we misperceive as a substantial autonomous entity. The lesson of psychoanalysis here is the opposite one: *one should not mistake reality for fiction* —one should be able to discern, in what we experience as fiction, the hard kernel of the Real which we are only able to sustain if we fictionalize it.

The true choice apropos historical traumas is not the one between remembering or forgetting. Traumas we are not able to remember haunt us all the more forcefully. One should accept the paradox that, to really forget an event, one must first gather the strength to properly remember it. In order to account for this paradox, one should bear in mind that the opposite of *existence* is not inexistence, but *insistence*. That which does not exist, continues to INSIST, striving towards existence.[6]

As such, is the 'passion for the Real' then to be rejected? Definitely not, since, once we adopt this stance, the only attitude remaining is one of refusal to 'save appearances'. The problem with the 20th-century 'passion for the Real' is not that it was a passion for the Real, but that it was a fake passion. Its ruthless pursuit of the Real behind the appearances was the *ultimate stratagem to avoid confronting the Real*.

<p style="text-align:center">***</p>

Apocalypse Now Redux from 2000, Francis Ford Coppola's reedited version of *Apocalypse Now*, stages in the clearest possible way the coordinates of a structural excess of state power. The main character, Kurtz, embodies the Freudian 'primordial father'— the obscene father, the total Master who dares to confront the Real of terrifying enjoyment face to face. He is presented not as a remainder of some barbaric past, but as the necessary outcome of modern Western power itself. Kurtz is a perfect soldier — as such, through his over-identification with the military power system, he turns into the excess which the system has to eliminate. The ultimate insight of *Apocalypse Now* is how power generates its own excess that it has to annihilate in an operation, which has to imitate what it fights. Willard's mission to kill Kurtz is nonexistent for the official record, 'it never happened', as the general who briefs Willard points out. We thereby enter the domain of secret operations, where Power operates without ever admitting it. Doesn't the same go for the contemporary figures presented by the official media as the embodiments of radical Evil? Is this

6 The first to articulate this opposition was, of course, Schelling, when, in his *Treatise on Human Freedom*, he introduced the distinction between Existence and the Ground of Existence.

not the truth behind the fact that Bin Laden and the Taliban emerged as part of the CIA-supported anti-Soviet guerilla fighters in Afghanistan, as well as behind the fact that Noriega (in Panama) was an ex-CIA agent? In all these cases, isn't the U.S. fighting its own excess? And wasn't this already true of Fascism? The liberal West had to join forces with Communism to destroy its own excessive outgrowth. What remains outside the horizon of *Apocalypse Now* is the perspective of a collective political act BREAKING OUT of this vicious cycle of the System which generates its superego excess and is then compelled to annihilate it: a revolutionary violence which no longer relies on the superego obscenity. This 'impossible' act is what takes place in every authentic revolutionary process.

Perhaps the best motto for today's analysis of ideology is the line quoted by Freud at the beginning of his *Interpretation of dreams: acheronta movebo* — if you cannot change the explicit set of ideological rules, you can try to change the underlying set of obscene, unwritten rules.

It is at this precise moment, in dealing with the raw Real of a catastrophe, that we should bear in mind the ideological and fantasmatic coordinates derterming its perception. If there is any symbolism in the collapse of the WTC towers, it is not so much the old-fashioned notion of the 'center of financial capitalism', but rather that the two WTC towers stood for the center of VIRTUAL capitalism, of financial speculations disconnected from the sphere of material production.

The shattering impact of the bombings can only be accounted for against the background of that borderline which currently separates the digitized first World from the Third World 'desert of the Real'. The awareness that we live in an insulated, artificial universe generates the notion that some ominous agent threatens us all the time with total destruction. Consequently, is Osama Bin Laden, suspected mastermind behind the bombings, not the real-life counterpart of Ernst Stavro Blofeld, the master-criminal in the James Bond films, responsible for acts of global destruction? The only space in Hollywood films where we witness the entire panoply of the production process is when James Bond penetrates the master-criminal's secret domain: a site of intense labor — distilling and packaging drugs, constructing a rocket that will destroy New York... When the master-criminal, after capturing Bond, takes him on the usual tour of his illegal factory, is this not the closest Hollywood comes to a house-proud, socialist-realist presentation of production? And the function of Bond's intervention, of course, is to

explode this site of production with fireworks, allowing us to return to the daily semblance of our existence in a world of the 'disappearing working class'. Is it not this violence, in the WTC towers explosions, re-directed from the threatening Outside back to us?

The safe Sphere in which Americans live is experienced as being under threat from the Outside by terrorist attackers, who are ruthlessly self-sacrificing AND cowards, cunningly intelligent AND primitive barbarians. The letters of the deceased attackers are quoted as 'chilling documents' — why? Are they not exactly what one would expect from dedicated fighters on a suicidal mission? If one takes away references to the Koran, in what way do they differ from, say, the CIA special manuals? Were the CIA manuals for the Nicaraguan contras, with detailed descriptions of how to upset daily life, even how to clog the toilets, not of the same order — if anything, MORE cowardly?

Whenever we encounter such a purely evil Outside, we should gather the courage to endorse the Hegelian lesson: in this pure Outside, we should recognize the distilled version of our own essence. For the last five centuries, the (relative) prosperity and peace of the 'civilized' West was bought by the export of ruthless violence and destruction into the 'barbarian' Outside: the long story from the conquest of America to the slaughter in Congo. Cruel and indifferent as it may sound, we should now, more than ever, bear in mind that the actual effect of these bombings is much more symbolic than real: in Africa, EVERY SINGLE DAY, more people die of AIDS than all the victims of the WTC collapse — and their deaths could have been easily cut back with relatively small financial means. The U.S. just got the taste of what goes on around the world on a daily basis, from Sarajevo to Grozny, from Rwanda and Congo to Sierra Leone.

Of course, the 'return to the Real' can take on various twists: one hears claims that what made us so vulnerable is our very openness. The inevitable conclusion lurks in the background: if we are to protect 'our way of life' we will have to sacrifice our freedoms which were 'misused' by the enemies of freedom. This logic should be rejected *tout court*: is it not a fact that our first World 'open' countries are the most controlled countries in the entire history of humanity? In the United Kingdom, all public spaces, from buses to shopping malls, are constantly videotaped, not to mention the almost total control of all forms of digital communication.

Along the same lines, Right-wing commentators like George F. Will immediately proclaimed the end of the American 'holiday from history' — the impact of reality shattering the isolated tower of the

liberal tolerant attitude and the Cultural Studies locus on textuality.
Now, we are forced to strike back, to deal with real enemies in the real
world. However, WHOM are we to strike back at? Whatever the response,
it will never hit the RIGHT target. The ridiculousness of America
attacking Afghanistan is glaring: if the greatest power in the world
bombards one of the poorest countries in which peasants barely survive
on barren hills, is this not the ultimate case of the impotent acting
out? Afghanistan is otherwise an ideal target: a country ALREADY
reduced to rubble, with no infrastructure, repeatedly destroyed by war
for the last two decades. One cannot avoid the surmise that the choice
of Afghanistan was also determined by economic considerations: is it
not convenient to act out one's anger at a country no one cares about,
where there is nothing left to destroy? Unfortunately, the choice of
Afghanistan echoes the anecdote about the madman who searches for
the lost key beneath a street light; when asked why he was searching
there, (since he lost the key in a dark corner), he answers: 'But it is
easier to search under strong light!' Is not the ultimate irony that, prior
to the U.S. bombing, the whole of Kabul already looked like downtown
Manhattan after September 11? Retaliation means to precisely avoid
confronting the true dimensions of what occurred on September 11th.
The 'war on terror' lulls us into the secure conviction that nothing has
REALLY changed.

It is already a journalistic commonplace that a new form of war
is now emerging: a high-tech war where precision-bombing does the
job, without any direct intervention of ground forces (if needed at all,
this job can be left to 'local allies'). Note the structural homology
between this new warfare at a distance, where a 'soldier' (a computer
specialist) pushes buttons hundreds of miles away, and the decisions of
managerial bodies which affect millions (IMF specialists at their
meeting dictating the conditions a Third World country has to meet in
order to merit financial aid, WTO regulations, corporate boards
deciding about necessary 'restructuring'). In both cases, ABSTRACTION is
inscribed onto a very 'real' situation, sometimes causing horrific
destruction. The link between these 'structural' decisions and the
painful reality of millions is broken. The 'specialists' are unable to
imagine the consequences, since they measure the effects of their
decisions in abstract terms: a country can be 'financially sane' even if
millions in it are starving.

In the same way that we drink beer without alcohol or coffee
without caffeine, we are now getting war deprived of its substance
— a virtual war fought behind computer screens, a war experienced by

STUDY REVEALS:
DOG LOVERS LIVE
LONGER THAN
CAT LOVERS

its participants as a video game, a war with no casualties (on our side, at least). With the spread of the anthrax panic in October 2001, the West got its first taste of a new 'invisible' warfare. With regard to the information about what is going on, we, ordinary citizens, are totally at the mercy of the authorities. We see and hear nothing, all we know comes from the official media. A superpower bombs a desolate desert country and finds itself hostage to invisible bacteria — THIS, not the WTC explosions, is the first image of 21st-century warfare.

Instead of rashly acting out, one should confront these difficult questions: what will 'war' mean in the 21st century? Who will be 'them', if they are, clearly, neither states nor criminal gangs? One cannot resist the temptation to recall the Freudian opposition of the public Law and its obscene superego double: are the 'international terrorist organizations' not the obscene double of the big multinational corporations — the ultimate rhizomatic machine, all-present, although with no clear territorial base? Is this not the form in which nationalist and religious 'fundamentalism' accommodate to global capitalism? Do they not embody the ultimate contradiction, with their particular/exclusive content and their global dynamic functioning?

There is a partial truth in the notion of the 'clash of civilizations' attested here. Witness the surprise of the average American: 'How is it possible that these people display and practice such a disregard for their own lives?' Is the obverse of this surprise not the rather sad fact that we, in the first World countries, find it more and more difficult even to imagine a public or universal Cause for which one would be ready to sacrifice one's life? After the WTC bombing, the Taliban foreign minister said that he can 'feel the pain' of the American children: did he not thereby confirm the hegemonic ideological role of this, Bill Clinton's trademark phrase? It effectively appears as if the split between first World and Third World runs more and more along the lines of the opposition between leading a long satisfying life full of material and cultural wealth, and dedicating one's life to some transcendent Cause. Two philosophical references immediately impose themselves apropos this ideological antagonism between the Western consumerist way of life and the Muslim radicalism: Hegel and Nietzsche. Is this antagonism not the same between what Nietzsche called 'passive' and 'active' nihilism? We in the West are the Nietzschean Last Men, immersed in stupid daily pleasures, while the Muslim radicals are ready to risk everything, engaged in the struggle up to their self-destruction.

If one perceives this opposition through the lens of the Hegelian struggle between Master and Servant, one notes the paradox: although we in the West are perceived as exploiting masters, it is us who occupy the position of the Servant, clinging to life and its pleasures unable to risk his life, (as in Colin Powell's notion of a high-tech war with no human casualties), while the poor Muslim radicals are Masters, ready to risk their lives.

However, this notion of the 'clash of civilizations' must be thoroughly rejected: what we are witnessing today are rather clashes WITHIN each civilization. A brief look at the comparative history of Islam and Christianity tells us that the 'human rights record' of Islam (to use this anachronistic term) is much better than that of Christianity: in the past centuries, Islam was significantly more tolerant towards other religions than Christianity. It is also through the Arabs, in the Middle Ages, that we, in Western Europe, regained access to our Ancient Greek legacy. While in no way excusing today's atrocities, these facts nonetheless clearly demonstrate that we are not dealing with a feature that is inscribed in Islam 'as such', but with the outcome of modern socio-political conditions.

On closer inspection, what, in fact, IS this 'clash of civilizations' about? Are all real-life 'clashes' not clearly related to global capitalism? The Muslim 'fundamentalist' target is not only global capitalism's corroding impact on social life, but ALSO the corrupted 'traditionalist' regimes in Saudi Arabia, Kuwait, etc. The most horrifying slaughters (those in Rwanda, Congo, and Sierra Leone) not only took place —and are taking place — within the SAME 'civilization', but are also clearly related to the interplay of global economic interests. Even in the few cases which would vaguely fit the definition of the 'clash of civilizations' (Bosnia and Kosovo, the south of Sudan, etc.), the shadow of other interests is easily discernible. A proper dose of 'economic reductionism' would thus be appropriate here. Instead of the endless analyses of how Islamic 'fundamentalism' is intolerant towards our liberal societies and other 'clash of civilization' topics, one should re-focus on the economic background of the conflict — the clash of ECONOMIC interests and the geopolitical interests of the U.S. itself: how to retain the privileged links with Israel AND with the conservative Arab regimes like those of Saudi Arabia and Kuwait.

Beneath the opposition of 'liberal' and 'fundamentalist' societies, 'McWorld versus Jihad', there are the embarrassing third term: countries such as Saudi Arabia and Kuwait, which are deeply conservative monarchies, yet American economic allies, and fully

integrated into Western capitalism. Here, the U.S. has a very specific interest: in order to count on these countries for their oil reserves, THEY HAVE TO REMAIN NON-DEMOCRATIC. The underlying notion is, of course, that democratic awakening can give rise to anti-American attitudes. This is an old story with the infamous first chapter in which, after World War II, the CIA orchestrated a *coup d'état* against the democratically elected Prime Minister Mosadegh in Iran in 1953. No 'fundamentalism' there, not even a 'Soviet threat', just plain old democratic awakening, and the idea that the country should take control of its oil resources and break up the monopoly of the Western oil companies. The U.S. are forced to explicitly acknowledge the primacy of economy over democracy, i.e. the secondary and manipulative character of their legitimizing international interventions by the so-called protection of democracy and human rights. (One cannot but note the significant role of the stock exchange in the bombings: the ultimate proof of their traumatic impact was that the New York Stock Exchange was closed for four days, and its opening the following Monday was a prime sign that things were returning to normal.)

Let us recall the letter of the 7-year-old American girl whose father is a pilot fighting in Afghanistan. She wrote that even though she love her father deeply, she would be ready to let him die, to sacrifice him for her country. When President Bush quoted these lines, they were perceived as a 'normal' outburst of American patriotism. Imagine an Arab Muslim girl pathetically reciting into the camera the same words about her father fighting for the Taliban. We do not have to think long what our reaction would have been: this would have been considered an outburst of morbid Muslim fundamentalism which does not hesitate to cruelly manipulate and exploit children. Every feature attributed to the Other is already present in the very heart of the U.S.: murderous fanaticism. In the U.S. today, there are more than two million Right-wing populist 'fundamentalists'; they, too, practice terror, legitimized by (their understanding of) Christianity. Since America is in a way 'harboring' them, should the U.S. Army have punished the U.S. itself after the Oklahoma bombing?'

7 According to some conservative U.S. lawyers, an act commited out of religious conviction by definition cannot be insane, since religion stands for the highest spiritual dimension of humanity. How, then, are we to categorize the Palestinian suicide bombers? Is their religious belief authentic or not? If not, does the same insanity label hold also for the American home-made Christian terrorists? What we encounter here is the old Enlightenment topic of the fragile borderline which separates religion from madness, or religious 'superstition' from pure 'rational' religion.

In the aftermath of September 11, Americans massively rediscovered their American pride, displaying flags and singing together in public. It should be emphasized more than ever, that nothing is 'innocent' about this rediscovery of the American innocence. It rid many of the sense of historical guilt or irony which prevented them from fully assuming to be 'American'. This gesture 'objectively' assumed the burden of all what being 'American' stood for in the past — an exemplary case of ideological interpellation, of fully assuming one's symbolic mandate, after the perplexity caused by historical trauma. In the traumatic aftermath of September 11, when the old security seemed momentarily shattered, what more 'natural' gesture was there than to take refuge in the innocence of ideological identification?[8] From the standpoint of the critique of ideology, it is precisely such moments of transparent innocence, when the gesture of identification seems 'natural', that are the most obscure ones — even, in a certain way, obscurity itself.

What about the phrase which reverberates everywhere: 'Nothing will be the same after September 11'? Significantly, this phrase is never further elaborated — it performs the empty gesture of saying something 'deep' without really knowing what we want to say. So, our first reaction should be: Really? What if, precisely, NOTHING EPOCHAL HAPPENED ON SEPTEMBER 11? What if – as the massive display of American patriotism seems to demonstrate — the shattering experience of September 11 ultimately served as a means for hegemonic American ideology to 'return to its basics', to reassert its basic ideological coordinates against the anti-globalist temptations? On September 11, the U.S. was given the opportunity to realize what kind of world it was part of. It MIGHT HAVE used the opportunity – but it did not, instead it opted to reassert its traditional ideological commitments: out went the responsibility and guilt felt towards the impoverished Third World. WE are the victims now!

Recall the collapse of the Communist regimes in Eastern Europe in 1990: people all of a sudden became aware that the game was over, that the Communists lost. The break was purely symbolic, nothing changed 'in reality' — and, nonetheless, from this moment on, the final collapse of the regime was just a question of days... What if something of the same order DID occur on September 11? Perhaps, the ultimate victim of the WTC bombings will be the big Other: the American Sphere. During Nikita Khruschev's secret speech at the 20th congress of the Soviet Party, in

8 I rely here on my critical elaboration of Althusser's notion of interpellation in chapter 3 of *Metastases of Enjoyment*, London: Verso Books 1995.

which he denounced Stalin's crimes, a dozen delegates suffered nervous breakdowns and had to be carried out and given medical care. Boleslaw Bierut, the hard-line general Secretary of the Polish Communist Party, even died of a heart attack days later. The model Stalinist writer Alexander Fadeyev shot himself days later. Not that they were 'pure Communists' — most of them were brutal manipulators without any subjective illusions about the nature of the Soviet regime. What broke down was their 'objective' illusion, the figure of the 'big Other' against the background of which they could exert their ruthless drive for power. The Other onto which they transposed their belief disintegrated. Is this not homologous to the events in the aftermath of September 11? Was 9-11 not the 20th congress of the American Dream?

One should bear in mind that Hollywood is the nerve center of the American ideology, exerting a worldwide hegemony. What draws millions of Third World people to the U.S.,— even those who are, with regard to their 'official' ideology, opposed to what America stands for, is not merely the prospect of material wealth, but also the 'American Dream', the chance to participate in it. The 'dream factory' Hollywood, functions to fabricate these hegemonic ideological dreams, to provide coordinates for private fantasies. In the post-September 11th era, the Hollywood machinery is perturbed and executives are desperately trying to guess and/or establish new rules. No more catastrophe movies: will single-hero movies as, for instance, James Bond movies survive? Will there be a shift towards family melodramas or blatant patriotism? It bears witness to the deep ideological impact of the September 11th events.

Until now, the U.S. perceived itself as an island exempt from this sort of violence, which was witnessed only from a safe distance on the TV screen, but which now finds itself directly involved. Will America decide to further fortify its 'Sphere'? Or will it take the risk and step outside of it? Either America will persist in the deeply immoral attitude of 'Why should this happen to us? Things like this don't happen HERE!', leading to paranoiac aggression towards the threatening Outside — or America will finally risk stepping through the fantasmatic screen which separates it from the Outside World. Thus it would accept its arrival in the Real world, making the long-overdue shift from 'A thing like this should not happen HERE!' to 'A thing like this should not happen ANYWHERE!'. Therein resides the true lesson of the WTC bombing: the only way to ensure that it will not happen HERE again is to prevent that it goes on ANYWHERE ELSE. America should learn to humbly accept its own vulnerability as a part of this world, enacting

the punishment of those responsible as a sad duty, instead of an exhilarating retaliation and a forceful reassertion of the EXCEPTIONAL U.S. role as a global policeman. The resentment against the U.S. results from the excess of its power, not the LACK of it.

One can also assert that the WTC bombing was an attack on the very center and symbol of global financial capitalism. This doesn't entail the compromise notion of shared guilt (terrorists are to blame, but, partially, Americans are also to blame…) — the point is, rather, that the two sides are not really opposed, but that they belong to the same field. The position to accept the necessity of the fight against terrorism SHOULD redefine and expand its terms to include also (some) acts by American and other Western powers. The choice between Bush and Bin Laden is not our choice, they are BOTH 'Them' against 'Us'. The fact that global capitalism is a totality, means that it is the dialectical unity of itself and of its other, the forces resisting it on 'fundamentalist' ideological grounds.

Consequently, of the two main narratives that have emerged from September 11, both are worse, as Stalin would have put it. The American patriotic narrative — the innocence under siege, the surge of patriotic pride — is, of course, vain. Was there not something petty and miserable in the mathematics that reminded one of the Holocaust revisionism (what are the 2823 accounted dead against millions in Rwanda, Congo, etc.)? And what about the fact that the CIA (co)created the Taliban and Bin Laden, financing and helping them to fight the Soviets in Afghanistan? Why was this fact quoted as an argument AGAINST attacking them? Would it not be much more logical to claim that it is precisely their duty to get rid of the monster it created? The moment one thinks in terms of 'yes, the WTC collapse was a tragedy, but one should not fully sympathize with the victims, since this would mean supporting U.S. imperialism,' the ethical catastrophe is already here. The only appropriate stance is the unconditional solidarity with ALL victims. The ethical stance proper is replaced here with the moralizing mathematics of guilt and horror, which miss the crucial point: the terrifying death of each individual is absolute and incomparable. Let us make a simple mental experiment: if you detect in yourself any restraint to fully empathize with the victims of the WTC collapse, if you feel the urge to qualify your empathy with 'yes, then what about the millions who suffer in Africa…?' you are not demonstrating your Third World sympathies, but revealing an implicit racist patronizing of Third World victims. The problem with such comparative statements is that they are necessary and inadmissible.

INSERT
MMERCIAL
HERE

I.

COM

One HAS to make them, but one HAS to make the point that much worse horrors are taking place around the world on a daily basis — but one has to do it without getting involved in the obscene mathematics of guilt.

Is the choice today really between liberal democracy and fundamentalism, or its derivations (like modernization versus resistance to it)? The only way to account for the complexity and the strange twists of today's global situation is to insist that the true choice is the one between capitalism and its Other (at this moment represented by marginal currents like the anti-globalisation movement). This choice is then accompanied by phenomena, which are structurally secondary, crucial among them the inherent tension between capitalism and its own excess. Throughout the 20th century, the same pattern is clearly discernible: in order to crush its true enemy, capitalism started to play with fire and mobilized its obscene excess in the guise of Fascism. However, this excess gained a life of its own and became so strong that the mainstream 'liberal' capitalism had to join forces with its true enemy (Communism) to subdue it. Significantly, the war between capitalism and Communism was a Cold one, while the big 'Hot War' was fought against Fascism. Is this not the same case as with the Taliban? After they had been used to fight Communism, they became the main enemy. Consequently, even if terrorism burns us all, the U.S. 'war on terrorism' IS NOT OUR STRUGGLE, BUT AN INTERNAL STRUGGLE OF THE CAPITALIST UNIVERSE.

America's 'holiday from history' was fake: America's peace was bought by the catastrophes going on elsewhere. These days, the predominant point of view is that of the innocent gaze confronting unspeakable Evil striking from the Outside. One should apply Hegel's well-known dictum that the Evil resides also in the innocent gaze perceiving Evil all around itself. Can one imagine a greater irony than the first codename for the U.S. operation against terrorists, 'Infinite Justice' (later changed in response to the protest of American Islamic clerics that only God can exert infinite justice)? Taken seriously, this name is profoundly ambiguous: either it means that America has the right to ruthlessly destroy not only all terrorists but also all those who lend them material, moral, ideological support. This process will be, by definition, endless in the precise sense of the Hegelian 'bad infinity', the work will never be really accomplished, there will always remain some other terrorist threat (and, effectively, in April 2002, Dick Cheney directly stated that the 'war on terror' will probably never end, at least not in our lifetimes). Or: it means that the justice exerted must

be truly infinite in the strict Hegelian sense, i.e. that, in relating to others, it has to relate to itself. In short, it has to ask the question of how we ourselves who exert justice are involved in what we are fighting against. On September 22, 2001, when Jacques Derrida received the Theodor Adorno award, he referred in his speech to the WTC bombings: 'My unconditional compassion, addressed at the victims of the September 11, does not prevent me to say it loudly: with regard to this crime, I do not believe that anyone is politically guiltless.' This self-relating, this inclusion of oneself into the picture, is the only true 'infinite justice'.

Against the cynical double-talk about 'infinite justice', one is tempted to recall the words of the Taliban leader Mullah Mohammad Omar in his address to the American people on September 25, 2001: 'You accept everything your government says, whether it is true or false. [...] Don't you have your own thinking? [...] So it will be better for you to use your sense and understanding.' While these statements are undoubtedly a cynical manipulation (say, what about giving the same right to use one's own sense and understanding to Afghanis themselves?), are they nonetheless, when taken in an abstract decontextualized sense, not quite appropriate?

IF I WERE TO KISS YOU
HERE THEY'D CALL IT
AN ACT OF
TERRORISM—SO LET'S
TAKE OUR PISTOLS TO
BED, WAKE UP THE CITY
AT MIDNIGHT LIKE
DRUNKEN BANDITS

HAKIM BEY

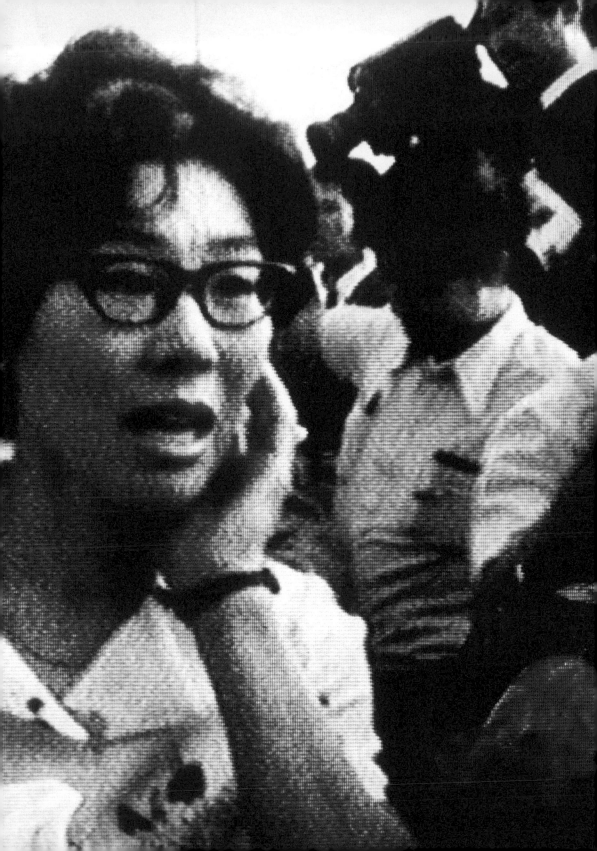

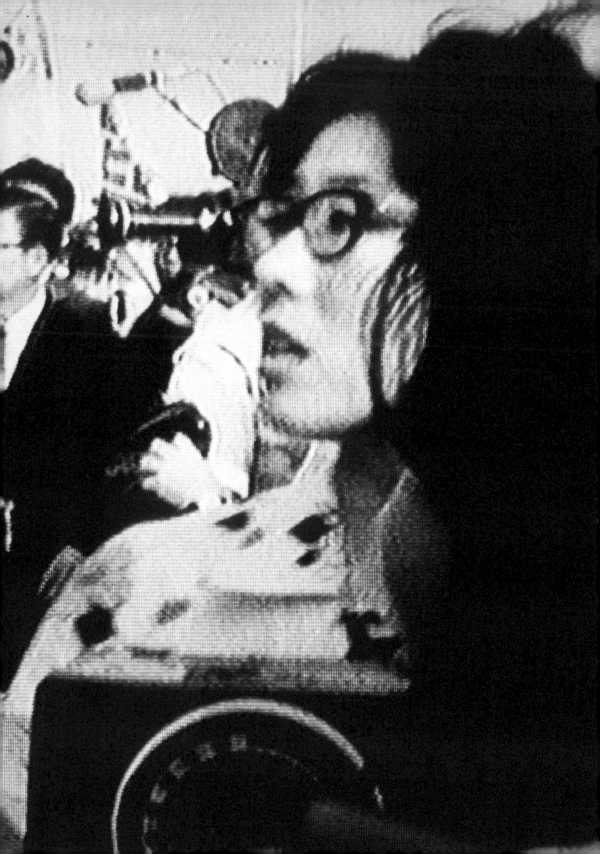

SHE TOOK IT ALL IN.
HE BELIEVED IT ALL.
PAIN, ECSTACY, DOG
FOOD, ALL THE
SERAPHIC MATTER, THE
BABY BLISS THAT FALLS
FROM THE AIR.

DON DELILLO, MAO II

INS
COMM
HE

ERT
ERCIAL
RE

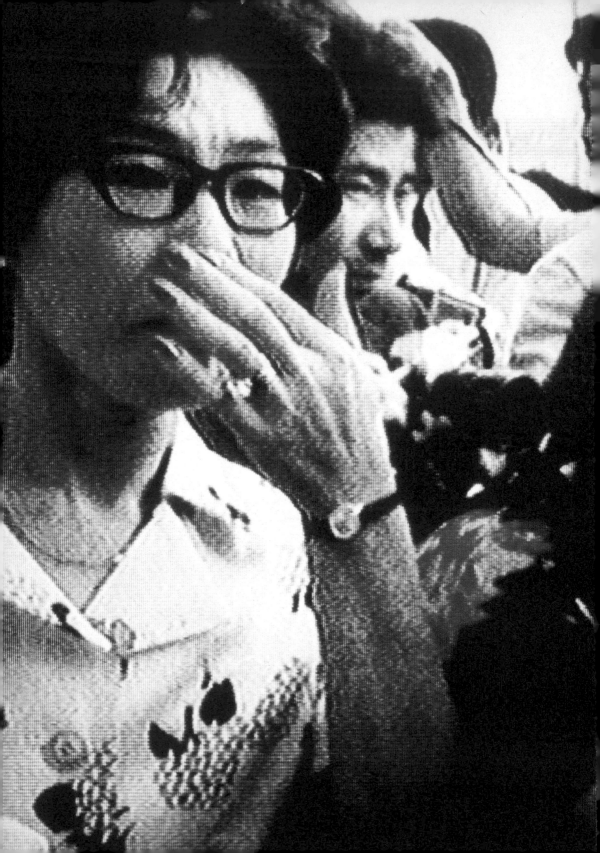

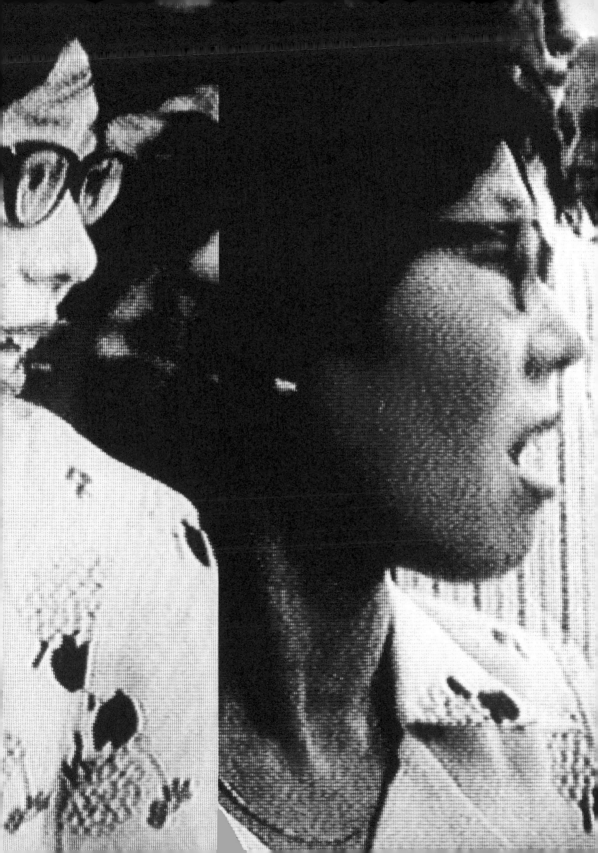

Reunion of Japanese couple
after JAL hijack
Nagoya Airport, 1973

> Email interview with Johan
> Grimonprez by Hans Ulrich Obrist
> May 1999
>
>
>
>
>
>
>
>
>
> Hans-Ulrich Obrist:
> A question about digital
> television: so far, digital
> channels are being watched by very
> few people. Does this 'non-Audimat'[1]
> situation create a laboratory,
> openness for experiments? To
> finally go beyond program
> television whose 'homogeneity...
> is intrinsically hostile to art'
> (Alexander Kluge)
>
> Johan Grimonprez:
> Couldn't homogeneity possibly
> trigger a creative context to read
> mainstream imagery in deviant ways,
> to read against the grain?
> Homogeneity, as a type of vocabulary,
> actually did provide a huge source
> of inspiration to explore certain
> themes in 'dial H-I-S-T-O-R-Y'. How
> do you struggle as an artist or
> filmmaker to position yourself vis-
> a-vis mainstream media? Art and
> mainstream media seem to remain mad
> twin sisters, always arguing. Hence
> the rivalry between a novelist and
> a terrorist staged as a metaphor in
> 'dial H-I-S-T-O-R-Y'. In this plot
> it's the terrorist who holds the
> winning hand, since he's able to
> play the media. The narrative is
> taken from DeLillo's book 'Mao II',
> which contends that the novelist's
> role within society has been
> replaced by that of bombmakers and
> gunmen. 'What terrorists gain,
> novelists lose,' says the book. The
> end of the film though alludes to
> the fact that the media nowadays
> might even be outplaying the
> terrorist.
>
> With 600 channels soon provided on
> New York cable, might the overall
> homogeneity not desire the other
> part: the urge for an extreme
> diversity, a kind-of-supermarket-

> idea with specialized departments,
> evidently to push the viewer's
> quota? The recent corporate merger
> of ATT-telephone, MediaOne &
> Microsoft might very well give new
> meaning to the act of zapping.
> Impossible to surf every channel
> in a night time. We are destined
> to plug in the computer-browser,
> let the search function pop up our
> favorite clips from the scifi-
> channel or the history-channel.
> We could also let a random-veejay-
> option simply perform the zapping
> for us, click for: TELEVISION ON
> MUTE and tune the stereo to some
> inflight groove.
>
> The homogeneity of mainstream
> imagery does not necessarily
> dictate a homogenous perception of
> that imagery. Video-viewing rituals
> amongst the Warlpiri community at
> Yuendumu (Central Australia) for
> example seem to sustain cultural
> invention. Decodings of Jackie Chan
> movies or Australian TV-soaps like
> 'Neighbours' would be interpreted
> along kinship obligations and
> different story-lines appropriate
> to Warlpiri narrative.[2] Similarly
> the gossip culture of catholic
> mothers in Northern Ireland would
> see Joan Collins from the
> feuilleton 'Dynasty' as an
> emancipatory icon: wasn't Joan rich
> enough to act independently and
> trash all those men? Translation of
> global culture across geographical
> (& political) boundaries can be
> read in most contradictory ways:
> commercials were the most powerful
> messages of the West, remarked East
> German writer Heiner Müller.
>
> The television viewer is maybe
> not a passive consumer: isn't there
> always a sense of appropriation,
> creating one's own terms to read
> mainstream imagery with a certain
> iconoclastic pleasure? It became
> the point of departure to set up
> a mobile videolibrary: 'Beware! In
> playing the phantom, you become
> one', a project made in
> collaboration with film critic
> Herman Asselberghs, and that has

> been travelling since its
> initiation in 1994.
>
> Hans-Ulrich Obrist:
> 'Beware! In playing the phantom...'
> includes films, documentary films,
> commercials, soaps and sitcoms. The
> program changed from Kassel to
> Paris where it was shown after
> Documenta X. How do you relate
> global issues through a travelling
> archive with local adaptations and
> local necessities? It is
> interesting that the program in
> Paris was different, it is no
> longer possible to send homogenous
> exhibitions on tours and impose
> them on places, but the terms have
> to be (re)negotiated every time.
>
> How do you integrate participatory
> elements into your films and other
> works in general?
> McLuhan speaks of hot and cold
> media, cold media being
> participatory media with few
> details, like paper, while hot
> media offer little possibility
> for participation, for example
> television.
>
> In an interview I recently made
> with Alexander Kluge he said that
> he tried to make films which are
> also, in your words: 'the ideology
> of zapping which can be an extreme
> form of poetry, going much further
> than collage'. Could you tell me
> about this last point, about how
> zapping transcends collage, where
> does it lead?
>
> Johan Grimonprez:
> The participatory elements would be
> sometimes as simple as a hot cup of
> coffee. We would never install our
> videolibrary without having the
> cookies, the smell of coffee and
> the remote control. These elements
> already induce a platform of
> conviviality, an atmosphere for
> chatting. You were invited to pick
> the remote to zap through your own
> choice of videotapes, in a way be
> your own curator. The stack of
> tapes that we put out range from
> twisted commercials, underground

> documentaries & alternative MTV to
> mainstream stuff optimed off from
> Hollywood & CNN. It would imitate
> a bit the domestic banality of
> everybody's homevideolibrary, and
> the visitors are also invited to
> include their own homegrown
> camcorder tapes: their honeymoon
> horrors, UFO-testimonies, their top
> ten of Oprah Winfrey Shows.
>
> The library alluded to the fact
> that the very act of watching
> television already contains a
> participatory nature. The way we
> receive, contextualize and
> recontextualize images. It's
> exactly what we do with the zapping
> tool (say: 'zaptitude'). Zapping
> buys into the supermarket ideology,
> but at the same time it can embody
> a critical distance as well. It
> stems in fact from videodeck
> terminology: zapping, i.e.
> fastforwarding the videotape past
> the commercial. Commercial break =
> zapping time.
>
> No need to zap though, the poetry
> is right there on CNN. CNN has
> totally surpassed the way
> Eisenstein and Vertov envisioned
> montage as a revolutionary tool.
> Similarly in how the avant-garde
> filmmakers of the 1960s & 1970s
> have become displaced by MTV's
> nature to swallow every different
> sort of novel style. The arrival of
> MTV on Moscovite TV in Russia was
> trumpeted in the Russian press as
> the biggest event since the 1917
> October revolution: Vertov
> reconsidered through the eyes of
> MTV.
>
> A zapping mode splices blood with
> ketchup, like CNN: images of war
> cut with strawberry ice cream.
> It would rather point at an
> epistemological shift in how a
> 'zaptitude' has transformed the
> way we look at reality. A jumpy
> fast forward vision has replaced
> our conventional models of
> perception and experience.
> Sometimes I don't even know anymore
> if we're still in the middle of the

> advert or whether the film has
> already started. We'll soon be
> mistaking reality for a commercial
> break.
>
>
> Hans-Ulrich Obrist:
> The taboo of visible death is
> usually kept from the public
> sphere into the private realm.
> 'dial H-I-S-T-O-R-Y' evokes
> Holbein's sarcophagus painting
> where the viewer is both inside
> and outside, the active and passive
> view coincide. Allegorical death
> and death as a dumb fact
>
> We are inside and outside, there
> is the obsession with death in
> 'dial H-I-S-T-O-R-Y' (You
> elsewhere described TV's complicity
> with death as 'the desire we have
> for the ultimate disaster is one
> aspect of our relationship with
> death'). It reminds us of what
> Georges Didi Huberman wrote about
> Sarcophage: 'Ce que je vois,
> ce que je regarde'[3]. In your text
> 'Kobarweng or where is your
> helicopter' you write: 'The
> observer observed'.
>
> Johan Grimonprez:
> Virilio remarked once that
> television turned the world into an
> accident, and that with the advent
> of virtual reality the whole of
> reality will be 'accidented'.
> Each technology invents its own
> catastrophe, and with it a
> different relationship to death.
> The boat invented the sinking of
> the boat, the airplane invented the
> crash of the airplane. Television
> has reinvented the way we perceive
> reality and the way we relate to
> catastrophe, history and death.
>
> TV has turned our notions of
> private and public inside out,
> but, more importantly, the
> representational modes for
> portraying actuality and
> imagination have become
> intertwined: CNN borrows from
> Hollywood and vice versa. The
> everyday talkshow has zapped the
> family right off their couch and

> into the studio. In the opposite
> direction catastrophe culture
> invades our living room.
>
> The territory of the home overlaps
> with the space of TV in a much more
> profound and psychological way than
> we are possibly aware. 'dial
> H-I-S-T-O-R-Y' ends also with a
> scene of a hijacked, crashing plane
> accidentally framed by some
> honeymooner's camcorder. The couple
> were immediately invited to be
> guests on Larry King's talk show on
> CNN to tell how they were able to
> shoot the footage! The dynamics of
> abstract capitalism thus allow
> the spectators to be the heroes and
> political issues are simply reduced
> to explanations of how to operate
> a camcorder. Patricia Mellencamp[4]
> calls it the shift from catastrophe
> to comedy: 'We can't change the
> world, but we can change our
> socks,' according to one Nike ad:
> 'It's not a shoe, it's a
> revolution.'
>
> ////////////////////////////////

> 1
> 'Audimat' is a system corresponding
> to the 'Nielsen ratings' in North
> America.
>
> 2
> See Eric Michaels, 'Hollywood
> Iconography: A Warlpiri Reading', in:
> Phillip Drumond and Richard Paterson
> (editors), 'Television and its
> Audience'. International Research
> Perspectives, London (British Film
> Institute) 1987.
>
> 3
> Hans-Ulrich Obrist refers to the
> painting 'The body of the Dead Christ
> in the Tomb' from Hans Holbein the
> Younger (1521-22, Kunstmuseum Basel,
> 30cm x 200 cm).
>
> 4
> See Patricia Mellencamp, 'High
> Anxiety: Catastrophe, Scandal, Age
> and Comedy', Indiana University Press
> 1990.
>

MAYBE THE SKY IS
GREEN AND WE'RE
JUST COLORBLIND

BART SIMPSON

Mohamed Atta
American Airlines, Flight 11
Boston, September 11, 2001

1930–1950s

1931
FIRST RECORDED HIJACK:

Peruvian revolutionaries seize PanAm plane to drop pamphlets over Lima.

1940s

1947–1958
THE PROPELLER YEARS: ALWAYS THE 'WRONG SIDE' OF THE IRON CURTAIN

JULY 1947
FIRST POSTWAR HIJACK. ROMANIANS GO WEST.

SEPTEMBER 1948
FIRST SKYJACK ACROSS THE IRON CURTAIN. GREEKS GO EAST. NO APPLAUSE IN THE WEST.

1950s

FEBRUARY 17, 1958
ENTER THE JET SET AND A NEW WORD: 'HIJACK!'

North Korea: Red sympathizers skyjack across 38th Parallel. *The Times* adopts the term 'hijack'.

1958
NEW GUERRILLA TACTIC:
FIDELISTAS SKYJACK THEIR WAY TO POWER

Fidelistas initiate hijacking as guerrilla tactic. Hundreds of planes will change course to Cuba in years to follow and turn it into a Skyjacker's Haven.

1959
BOOMERANG:
REFUGEES HIJACK OUT OF CUBA. U.S. GRANT FIRST POLITICAL ASYLUM TO SKYJACKERS

1960s

1961–1972
BOOMERANG 2:
HONEY! WE'RE GOING ALL THE WAY … TO CUBA!

Flux of homesick Cubans jumpstart wave of hijackings to Havana.

1968
PALESTINIAN SKYJACK WAR HITS THE WORLD

The 1967 Six-Day War leaves 700,000 Palestinians homeless. On July 23, 1968 the Popular Front for the Liberation of Palestine (PFLP) reclaims territory in the sky, commandeering an Israeli plane to Algiers.

1969
HIJACK INN: CUBANS WINE AND DINE AMERICANO

By 1969 the restaurant and gift shop at the Havana airport expands their business to take care of the unexpected flux of visitors brought in by the skyjackers. Landing fees are inflated and the runway is enlarged to take care of the unscheduled joyrides to the Caribbean island.

A routine pattern establishes: hijackers are lodged in the 'Casa de Transitos' ('Hijacker's House') in Havana's Siboney district. Pilots and crew rest briefly, smoke cigars, and then fly their empty planes back to the U.S. Cubans wine and dine the Americano tourists and take them on a sightseeing tour of socialist Cuba. After this memorable side trip, generally enjoyed by the visitors, they are boarded on a return trip to the U.S., laden with rum, cigars, revolutionary literature, sombreros and pictures of Che Guevara.

DECEMBER 28, 1968

Israeli commandos swarm Beirut Airport blowing up 13 Arab jets in reprisal to a PFLP attack on an Israeli Boeing 707.

AUGUST 29, 1969
LEILA KHALED TAKES AMERICAN TWA FLIGHT OUT OF ROME ON A 7-MIN DETOUR OVER HER OCCUPIED HOMELAND

NOVEMBER 1, 1969
FIRST TRANSATLANTIC HIJACK:
VIETNAM VET RAFFAELE MINICHIELLO HIJACKS AMERICAN AIRLINER TO ROME

Vietnam vet Raffaele Minichiello forces a TWA Flight 85 out of Los Angeles to make a detour across two continents and an ocean. Two days and 6,869 miles later they arrive in Rome, accomplishing the world's longest skyjack. He spent $15.50 on his plane ticket. Raffaele's skyjacking is acclaimed as the most exciting event since the eruption of Mount Vesuvius. Touted as victim of the imperialist American war machine, he becomes an instant celebrity. Marriage proposals pour in. Movie starlets and models tearfully confess their love, and Minichiello is offered a leading role in an Italian spaghetti western.

1970s

1970
FIRST JUMBO JET 747 HIJACKED

1968-72
SKYJACK ROUTE TO CUBA: BLACK PANTHERS ON THE RUN, FBI IN SWIMMING TRUNKS

In 1972 bathing trunks become standard uniform for FBI agents. On November 10, three Black men, Henry Jackson and his two half-brothers — Lewis Moore and Melvin Cale, overpower Captain William Haas of a Southern Airways Flight 49 out of Birmingham, Alabama. Paranoid that the other male passengers conceal weapons, the hijackers have them all strip down to their underwear. The women are ordered to throw their purses in the aisle. During that time they also serve dinner. The hijack turns into a two-day ordeal across the U.S., Canada, Cuba and the Atlantic; making nine forced stops, two of them in Havana.

MARCH 31, 1970
SKYJACK CAPTURES TELLY!
TOKYO STREETS DESERTED:
MILLIONS WATCH FIRST TELEVISED HIJACK

SAMURAI HAIJAKKU! The Japanese Red Army (JRA) goes international with the very first airliner to be hijacked in Japan. Armed with Samurai swords, nine JRA-members force a Japanese Airliner out of Tokyo to fly to North Korea in an attempt to reach Cuba. They get stalled in Seoul: South Korea's Kimpo International Airport is disguised as a North Korean air base for the occasion, to mislead the hijackers. Communist banners replace South Korean flags, English signs are removed, and two trucks of airborne troops in stolen North Korean uniforms roll in. The set up fails: American jazz radio is detected and gives the ruse away. The Samurai incident hits the screen live, unfolding over 84 hours before a television audience of millions. New word enters Japanese vocabulary: 'Haijakku'.

JUNE 15, 1970
REFUSHNIKS: OFFICIAL REQUEST DENIED
SOVIET JEWS SKYJACK THEIR WAY TO ISRAEL

St. Petersburg authorities give Jewish hijackers death sentence. In Jerusalem hundreds flock to Wailing Wall to demonstrate.

SEPTEMBER 6, 1970
PFLP TURNS PALESTINE INTO HOUSEHOLD NAME

The Popular Front for the Liberation of Palestine (PFLP) upgraded the Cuban skyjack strategy into a worldwide political phenomenon. Palestinians turned to hijacking as a weapon to communicate their cause to an international audience. The potential of television as a means to affect worldwide opinion was accidentally realized during the Samurai incident in the spring of 1970. The impact was not lost on the PFLP. The strategy: Turn your cause into prime time. The method: Hold passengers hostage in full view of TV cameras, negotiate with political authorities while the world watches. The stage is set for the most daring plot in the history of civil aviation:

QUADRUPLE SKYJACK SUNDAY OVER EUROPE:
600 passengers plucked from the sky. Destination: 'Revolution Airstrip'. Two jets to desert; 3rd jet blown up on Cairo runway; 4th plane foiled, Leila Khaled captured; 5th plane seized — demand: Khaled's release. Security features now commonplace at airports worldwide. *The Times* proclaims 1970 as, 'Year of the Hijacker'.

1969-1970
LEILA KHALED'S SKYJACK DIARY

August 29, 1969: A stylishly clad Leila Khaled in white bell-bottoms and matching hat, boards TWA Boeing-707 on its way from Rome to Tel Aviv. Once airborne her other accessories appear: a pistol and a hand grenade. As she makes her way toward the cockpit, her companion, Salim Issawi, announces that the Popular Front for the Liberation of Palestine is now in command of the very first American airliner hijacked in the Middle East. Captain Carter, looking down the barrel of a pistol, is obliged to agree.

After a celebrity-tour of the Arab world, Leila Khaled undergoes facial plastic surgery to prepare her for her second rendez-vous with history. Ever Since the 1969 TWA hijack episode, Khaled's picture plasters the walls of airports world wide, yet there is hardly a glimmer of recognition as the veteran skyjacker boards an El Al flight bound for New York. This time her companion is Patrick Arguello and she wears a 'wonderbra' made of two grenades. They attempt to divert the plane to join their comrades at a deserted military airstrip in the Jordanian desert. On the infamous 'SkyJack Sunday', a quadruple hijack scenario was masterminded by the Palestinian Front, but the El Al hijack is foiled and Leila Khaled apprehended. Three days later, the PFLP seizes a 5th plane to negotiate her release from prison.

1970s

1971–1972
ENTER THE PARAJACKER. EXIT THE MONEY.

North America: Thank God it's Skyjack Friday! Hijack
buzzer hits alert every week.

MAY 8, 1972
LOD AIRPORT, TEL AVIV: BLACK SEPTEMBER MASQUE!

 FIRST ASSAULT ON HIJACKED PLANE: Israeli
commandos in mechanic's gear. Palestinian
girls in exploding girdles and detonator
wonderbras.

Incognito, in wigs and forged passports,
four Palestinians board a Sabena jet at
Brussels Airport. Of the four, two are
Palestinian girls, Rima Tannous Eissa, 21,
and Therese Halaseh, 19. Both girls wear special girdles
made of highly explosive material; each have a hand
grenade hidden in their beauty-cases with the detonators
tucked in their bras. Approaching Sarajevo, the girls
go to the washroom to remove their girdles: Rima handles
the explosives, while Therese announces to the
passengers over the intercom that they are being
skyjacked by the Black September unit of the Palestinian
guerrilla organization. They touch down in Tel Aviv
demanding the release of 317 Palestinian commandos held
in Israeli prisons. They ask that their demands be met,
or else they will blow up the plane with the passengers.
In the first successful assault carried out on a
passenger airliner, Israeli soldiers, disguised as
mechanics, storm the plane and shoot the two male
commandos and one passenger.

1972–77
TERRORIST (AND COUNTERTERRORIST)
SWAP SHOP: LET'S TRADE HIJACKINGS

RAF, JRA & PFLP trade Kalashnikovs, passports and
hijackings.

DECEMBER 21, 1975
VIENNA: SHOOTOUT AT OPEC

International Playboy revolutionary Carlos, AKA 'the
Jackal', crashes the OPEC (Organization of Petroleum
Exporting Countries) convention in Vienna. Eleven oil
Sheiks and Ministers are captured: the richest and most
powerful group of hostages in history ever. Carlos
demands an airplane and shortly after, he and his
prisoners are jet set.

1976–1977
COUNTERTERRORIST TEAMS AT ENTEBBE
AND MOGADISHU ADOPT 'SHOOT-TERRORIST-
ON-SIGHT' DOCTRINE.

1980s

JUNE 1985
TERRORISM IS WHAT THE BAD GUYS DO:
RONALD REAGAN HOSTS SHI'ITE PRIMETIME
AND HIJACKS TV

Beirut-Algiers: Shi'ites commandeer TWA Flight 847.
Media spectacle deflects from Reagan administration's
clandestine activities in Central America: the one
American hostage killed in the Middle East eclipses
10,000 people killed in Central America.

GOVERNMENTS PLAY TERRORIST:
JUMBOJETS DROP FROM THE SKY

SEPTEMBER 1, 1983
JAMES BOND: FLIGHT NUMBER 007

The 'Evil Empire' strikes again! Soviet fighter launches
missile at Korean passenger plane that strays into
sensitive USSR military zone. The downed plane crashes,
killing 269. Genuine spy mission enlisted by the Reagan
administration? Flight number: 007!

FEBRUARY 4, 1986

Israeli fighters pirate Libyan Air in an attempt to
capture Palestinian leader. Security Council at the
United Nations condemns Israeli air piracy. U.S. vetoes.

APRIL 4, 1986
LONDON, HEATHROW: BUSTED!

Nezar Hindawi puts unsuspecting (and pregnant)
girlfriend on a flight to Israel; her bag lined with
enough semtex to blow up the plane. Inside the bag a
pocket calculator fitted with detonator. Luckily, she
was busted. Rumors of a double agent double cross.
The official version is that the bomb was allegedly
crafted by Syrian intelligence operatives and passed
to Hindawi by his Syrian handlers. However, French
Prime Minister Jacques Chirac (*Le Monde*, November 11,
1986) cites the West German Government as authority for
the alleged involvement of the Israeli Secret Service
in the attempted bomb plot as a provocation designed
to embarrass Syria and destabilize the Assad regime.
The Heathrow bomb was never intended to go off, and its
discovery by an Israeli security guard was a mere
charade.

JULY 3, 1988
PERSIAN GULF: MISTAKEN IDENTITY 2

USS Vincennes misidentifies Iranian civilian airliner as
a hostile F-14 military fighter plane. The plane,
carrying 290 Muslims on Hajj to Mecca, is downed. U.S.
claims non-liability in 'Right of Self-Defense at
International Law'. Legally suspect: the U.S. is not
officially at war. Iran, however, calls it an act of war.

DECEMBER 21, 1988
SUITCASE 'HOT POTATO'

Iranian Ministry of Interior contracts Syrian based
Ahmed Jabril (PFLP-GC) to blow up American airliner in
retaliation for the downed Iranian Airbus. Mission fee:
$10 million. Result: suitcase bomb rips PanAm Jumbojet
out of sky over Lockerbie; 270 lives lost. PanAm blames
CIA; CIA blames Libya; Terrorists worldwide claim blame.

JULY 18, 1996
TWA FLIGHT 800 TURNS X-FILE

Satellite images suggest missile as cause of explosion
for TWA Flight 800. Other sources link the incident to
a UFO scenario. U.S. government has no comment.

AUGUST 1994
MORIOKA, JAPAN: TOURIST HIJACK

TRAIN PASSENGERS PAY TO BE HIJACKED AND TAKEN HOSTAGE:
600 tourists board a Japanese bullet train with the
thrill of knowing they will be terrorized and taken
hostage. They paid $400 each for the experience. The
tourists, mostly women, took the ride as part of a mock
hijack sponsored by a theatre company and Japan's
National Railway. Like any good mystery, the passengers
and the organizers had various motives participating in
the scheme. The producer and writer who developed the
plot said it was a good way to get their work seen. The
Train Company was pleased too: the entertainment helped
them sell seats.

1990 >>
FROM CHECHNYA WITH LOVE:
NEW NATIONS, NEW JACKS

Eastern block topples,
skyjacking on the rise.

NOVEMBER 23, 1996
MORONI, COMORO ISLANDS:
HONEYMOONERS VIDEOTAPE HIJACK HORROR!

Larry King Live:
CAMCORDERS TURN SPECTATOR INTO HEROES.

SEPTEMBER 11, 2001
INDEPENDENCE DAY REALTIME

Cause clashes with effect as America's
political unconscious returns to haunt it.
The dark underside of repressed world
politics strikes back: flying objects
appear out of nowhere, Hollywood disaster
style, and demolish the trade towers.

OCTOBER 5, 2001
FEDS ENLIST HOLLYWOOD

Government intelligence, at the behest of the U.S. Army,
meet with top Hollywood filmmakers and writers at the
Institute for Creative Technology at the University of
South California. Their mission: to solicit possible
terrorist scenarios.

PUBLISHED BY

argos editions
Werfstraat 13
B-1000 Brussels
t +32 2 229 00 03
f +32 2 223 73 31
info@argosarts.org
www.argosarts.org

Hatje Cantz Publishers
Senefelderstraße 12
73760 Ostfildern-Ruit
Germany
t +49 7 11 44-05-0
f +49 7 11 44-05-220
www.hatjecantz.de

zap-o-matik
Ghent/New York
www.zapomatik.com

DISTRIBUTION

EUROPE
Book trade by Hatje
Cantz Verlag and its
distribution partners

DVD trade by argos
editions

U.S.
Book trade by
D.A.P., Inc.
155 6th Avenue,
New York, 10013-1507
t +1 212 6 27 19 99
f +1 212 6 27 94 84
dap@dapinc.com
www.artbook.com

JAPAN
DVD trade by
Imageforum/Daguerro
Press Inc.
2-10-2, Shibuya,
Shibuya-ku
J-150-0002, Tokyo
t +81 3 5766 1119
f +81 3 5466 0054
info@imageforum.co.jp
www.imageforum.co.jp

PRINTED BY

Dr. Cantz'sche Druckerei,
Ostfildern, Germany

DESIGN

Peter Bilak
www.peterb.sk

TEXT CREDITS

*A HOLIDAY FROM HISTORY,
and other real stories*;
Slavoj Žižek.
Originally published in
Janus #9/2001 (Antwerp).
A different version is
published under the
title *WELCOME TO THE
DESERT OF THE REAL*;
Wooster Press (New York)
2001; ed. Josefina Ayerza
© Slavoj Žižek 2001

*ON SEEING, FLYING AND
DREAMING*; Vrääth Öhner.
Originally published in
Camera Austria #66/1999
(Graz). A different
version is published for
Factor 1997, FACT
(Liverpool) 2002; ed.
Claire Dohorty.
Translation from German:
Richard Watts
© Vrääth Öhner / Camera
Austria 1999/2002

*EMAIL INTERVIEW WITH
JOHAN GRIMONPREZ
BY HANS ULRICH OBRIST,
May 1999*.
Originally published in
Camera Austria #66
(Graz) 1999
© Johan Grimonprez/Hans
Ulrich Obrist/Camera
Austria 1999

Parts of the SKYJACKER'S
TIMELINE were compiled
by Herman Asselberghs &
Johan Grimonprez and
appeared under the title
NERGENSLAND in *Dietsche
Warande & Belfort*
(Leuven) October 1997. A
larger version appeared
in *INFLIGHT*, Johan
Grimonprez; Hatje Cantz
Publishers, 2000; eds.
Onome Ekeh & Daragh
Reeves
© Johan Grimonprez

QUOTES

Chechen Ganster: Quoted
in *GOVERNING THE LAST
CONTINENT?*, Takakazu
Akahane; *SUBETAGE*
(Vienna) 1999

Don DeLillo: *MAO II*; by
permission of the author
and the Wallace Literary
Agency Inc. (New York)
1991

Hakim Bey: *TAZ*,
Autonomedia (New York)
1985

TEXT EDITORS

Onome Ekeh
Daragh Reeves

PHOTOGRAPHY CREDITS

Johan Grimonprez &
Rony Vissers.
Courtesy ABC News
Videosource (New York).
dial H-I-S-T-O-R-Y
© 1997 Johan Grimonprez
Cover: Three hijacked
planes being destroyed
on desert airstrip in
Amman, Jordan, on
September 12, 1970

SPECIAL THANKS

Don DeLillo
Hans Ulrich Obrist
Vrääth Öhner
Peter Lamborn Wilson
Slavoj Žižek

ACKNOWLEDGEMENTS

Herman Asselberghs
Todd Ayoung
Kristien Daem
Jeffrey Deitch
Frie Depraetere
Claire Dohorty
Cendrine du Welz
Sharon Essor
Kendell Geers
Geraldine Grimonprez
Markus Hartmann
Dominique Marcel
Roger McKinley/Mites
Roger Tatley
Rony Vissers
Paul Willemsen
Koyo Yamashita

dial H-I-S-T-O-R-Y

by Johan Grimonprez

Belgium-France,
color & black/white,
68 min, stereo

DVD NTSC no zone, 2003
After the original
Digital Betacam, 1997

ORIGINAL LANGUAGE English
SUBTITLES French, Dutch,
German, Spanish,
Portuguese, Japanese,
Galician

EXCERPTS

Mao II, and *White Noise*,
Don DeLillo
ORIGINAL MUSIC &
SAMPLE COLLAGE
David Shea
WRITTEN & DIRECTED
Johan Grimonprez

PRODUCED BY

Centre Georges Pompidou,
MNAM, Service Nouveaux
Médias, Paris & Kunsten-
centrum STUC, Leuven
WITH THE SUPPORT OF
Documenta X (Kassel)
Klapstuk 97 (Leuven)
Fundación Provincial de
Cultura (Cádiz), The
Fascinating Faces of
Flanders, Ministerie van
de Vlaamse Gemeenschap,
Belgium.

Excerpts from *White
Noise* (Don DeLillo,
1984-1985) and *Mao II*
(Don DeLillo, 1991) are
used by permission of
the author and the
Wallace Literary Agency
Inc. (New York)

PROJECT CONCEPT

incident (Brussels);
zap-o-matik (Ghent)
DVD EDITION
argos (Brussels);
zap-o-matik (Ghent)
DVD EDITION MASTERING,
ENCODING & PRINTING
Studio l'Equipe (Brussels)
Japanese subtitles:
Akira Tochigi; eds.
KS Graphics (Kumiko
Sawada) & Koyo Yamashita

MADE POSSIBLE WITH THE SUPPORT OF

Fonds Film in Vlaanderen,
Ministerie van de Vlaamse
Gemeenschap (Brussels)

D/2003/9073/1
ISBN 90-76855-12-9
(argos editions)
ISBN 3-7757-1267-4
(Hatje Cantz Publishers)
© 2003 argos editions,
Hatje Cantz Verlag,
zap-o-matik and the
authors